Leisure Arts 40

An Introduction to
Painting Birds in
Watercolour

Betsy Lee Wanner

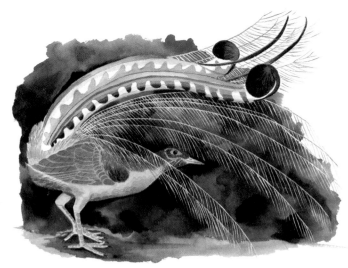

CW00952188

SEARCH PRESS

Introduction

Birds are often considered to be one of the most difficult subjects to portray, as they seem to present little opportunity for sustained sketching and study. However, even if it is not possible to actually sketch or photograph them, observing birds from life is the prime requisite for painting them, as it is the only way in which you can learn about their movement and behaviour. The more that you observe the living subject, the more skilled you will become at creating art which is lifelike.

The basis of my learning began when I was a child, spending many long winters drawing and painting the birds which visited the feeder that still hangs outside my parents' living room window. Now, my working method involves many different references, including working from life whenever possible, photographs, mounted museum specimens, and individual feathers that I have collected over the years. I keep a morgue in my studio, which is simply an indexed box containing reference photographs, filed under special headings such as birds of prey, marsh birds, songbirds, and so on. When I am in the field, I do quick drawings, make colour notes, and photograph anything that looks interesting. Mushrooms, old stumps, and bark textures are all potential prey for a bird artist's camera and sketch-book.

The ideal way to work from life would be to go out into the field and draw birds in their natural habitat. However, most birds have a habit of leaving the scene prematurely, or are too small and too far away for accurate rendering. So, much of the time, I find that I must modify my field studies by going to where the birds are more adapted to people. Some good places to visit for life drawing are zoos, parks, pet shops, and wildlife centres. Also, I still recommend bird feeder observation, as it is often the best way to capture the small birds in drawing.

When working from life, I photograph my subject first, using a 35mm camera and 300mm lens. Although the camera is not essential, it lessens my research time later, should I need to consult other reference sources when adding details to the drawing. Then, I make a number of on-the-spot sketches to capture the bird's basic form and position. I always return to the studio to complete my drawings and decide upon the final one that I wish to paint.

In this book I have included a number of drawings and demonstration paintings to show you how to sketch birds from life and then develop these drawings into finished paintings. With careful observation and practice, I am sure that you will soon develop the confidence to adapt these methods and create your own original compositions. I hope, too, that in the process you will discover the endless delights of painting birds.

Materials and equipment

Paints

Watercolour paints are available both in tubes and in cake form. I used tube colours for the paintings in this book, but dry cake colours work well too and, in fact, are more economical for small paintings because there is no excess paint to discard. Artists' quality paints are my first choice, but high quality student paints can also be used.

Papers

When painting, I like to work on different papers, in order to achieve various effects. Three excellent papers are Whatman cold-pressed, Arches cold-pressed, and Fabriano hot-pressed. Whatman is a soft, very white paper that absorbs much paint and yields luminous colours. Arches is creamy white and highly sized, so it will take more handling in the way of correcting mistakes and erasing pencil lines. Fabriano hot-pressed is a bright white, smooth but absorbent paper that works well for the small birds and finer detail. Papers come in different weights, or thickness. The paintings in the book have been done on an Arches 300gsm (140lb) paper, which is a medium weight.

For life drawing and preliminary studies, I use large amounts of inexpensive sketching paper. Also, I find

tracing paper and graphite paper essential for completing my drawings and transferring them on to the watercolour paper.

Brushes

The majority of my paintings are executed with one or two brushes, a No. 4 round brush and a flat brush, either 2cm (¾in) or 2.5cm (1in) in size. I like using good, high quality synthetic sables for this type of work, as they cost less than real sable and perform just as well. After several paintings, when I find that I must replace a brush with a worn tip, it is much easier to part with a brush that has not represented a substantial investment. It was a long time, however, before I trusted these newer synthetics to do the job of my old friends, the red sables, which have long held the number one position in my studio.

Whatever brush is chosen, whether it is synthetic or red sable, certain qualities must be present in order for it to work with maximum efficiency. I always test the brush by running my thumb lightly over the bristles; they should spring back willingly and not remain tilted to one side. Round brushes should point up when wet. The sizing is first rinsed out of the brush, then it is lightly tapped to get some of the water out of it. It should come to one point, with no hairs going off to either side. I test my brushes frequently, as points wear off sooner than might be expected. 'Retired' brushes are used for large work such as laying in washes.

Palette

My main requirement for a mixing palette is that it should be white, and I often use white plastic container lids for small paintings. Something with compartments or wells is better for larger paintings where greater quantities of paint and water will be used. A palette that is made for this purpose has a colour mixing area in the centre, but discarded ice-cube trays can be used just as well.

Other equipment

Other miscellaneous items that will be useful include paper towels or rags, scrap paper to test colours, and a kneadable putty eraser to remove graphite lines without damaging the paper surface.

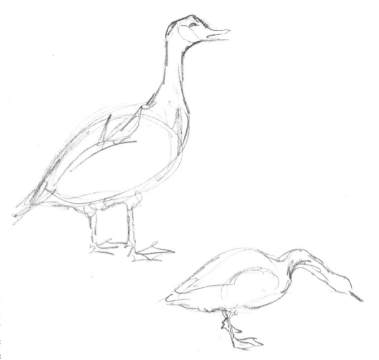

The structure of a bird

A knowledge of a bird's physical characteristics will greatly enhance your ability to portray it accurately. The general topography of a bird is shown overleaf.

Each bird species has its own distinguishable set of characteristics, as well as some features common to all. For example, a wing is a complicated structure consisting of specialized feather groups. The size and shape of the groups may vary with the species, but every wing will have the same group of feathers. Most primary wing feathers have a shape similar to that of a knife, to facilitate cutting through the air during flight. Falcons, ducks, and other rapid fliers have a more pronounced edge to these flight feathers, whilst birds which fly silently, such as the owl, demonstrate a softer and more rounded feather shape. In most birds there are about ten primary wing feathers, but secondaries vary in number.

Even though all of these features may not show in your painting, it is still important to study your subject and have such information at hand.

Topography of a bird

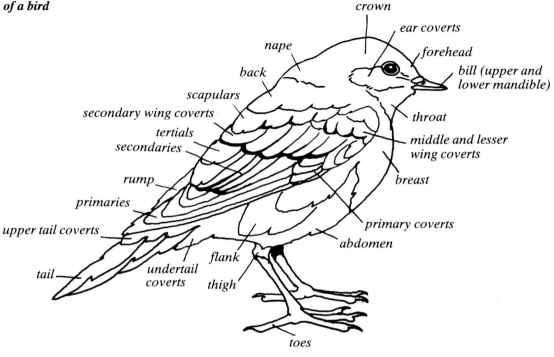

crown
ear coverts
forehead
bill (upper and lower mandible)
nape
back
throat
scapulars
secondary wing coverts
middle and lesser wing coverts
tertials
secondaries
breast
rump
primaries
primary coverts
upper tail coverts
abdomen
tail
undertail coverts
flank
thigh
toes

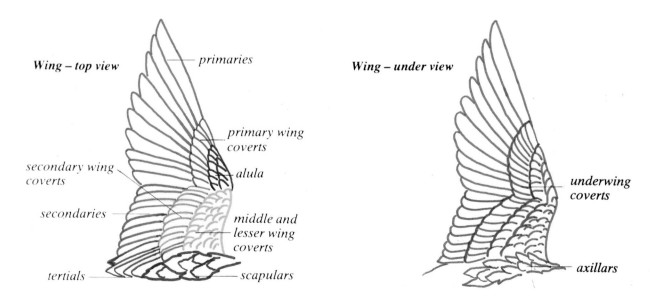

Wing – top view
primaries
primary wing coverts
alula
secondary wing coverts
secondaries
middle and lesser wing coverts
tertials
scapulars

Wing – under view
underwing coverts
axillars

*These sketches help to illustrate the
wide diversity of bird features.*

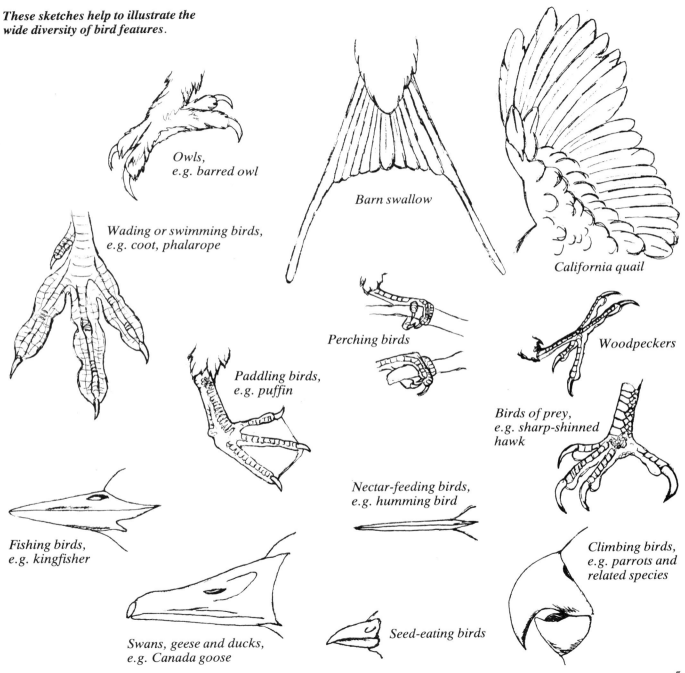

Owls,
e.g. barred owl

Wading or swimming birds,
e.g. coot, phalarope

Barn swallow

California quail

Perching birds

Woodpeckers

Paddling birds,
e.g. puffin

Birds of prey,
e.g. sharp-shinned
hawk

Nectar-feeding birds,
e.g. humming bird

Fishing birds,
e.g. kingfisher

Climbing birds,
e.g. parrots and
related species

Swans, geese and ducks,
e.g. Canada goose

Seed-eating birds

5

Basic drawing techniques

It is important that your first attempts are enjoyable, so do not try too hard. Improvement comes with practice, and you may not want to if you tire in the beginning. You will need a sketch-book of inexpensive paper and a pencil or a ball-point pen. Start with subjects that do not move; museum specimens, photographs in books, postcards, even birds which have been killed on the road if they are fresh.

Either of two techniques, gesture drawing or form drawing, may be used. Gesture drawing is done quickly to capture form and movement without having to worry about details. It is a good method to use when working from life, as refinements can be done later with the aid of photographs. Beginning with an oval for the body, form drawing uses basic shapes to block in the bird's structure. The drawing is then completed with modification of these forms and the addition of other features.

Practise until it becomes easy for your hand and eyes to work together in forming the ovals and distinctive shapes which define your subject. At this point, do not try to add detail. Erasing is also unnecessary and will slow down the entire process. If you are tempted to erase, then sketch with a ball-point pen instead of a pencil. If any lines need to be corrected, then draw straight over the old ones. You may fill many sheets of paper with your sketches before you are comfortable with the techniques. Keep your sketches as a record of your improvement, and write down the date and place where they were made.

Drawing live birds

Use the same practice techniques for your live subjects, and do not worry about detail or mistakes. Work quickly, and work straight over errors, or begin again. For home study, a camera is useful if your subject is large or close enough. The lens that I use most often is a 300mm. If you own a video-cassette recorder, then you can play nature videos and use these to practise from 'life' in your own living room.

Completing your drawing

The completion of your drawing will take the most time. This is where the photographs that you may have taken, or outside reference sources such as those mentioned in the introduction, will be used. As you add your detail, carefully study the topography of your bird. Your final goal should be to become so familiar with the appearance of your subject that you will be able to compose much of it from memory. This will allow you the freedom eventually to create your own artwork without being entirely dependent on visual aids.

Once I have returned to the studio, armed with my preliminary sketches and life studies, I employ the following steps to complete the drawing. Firstly, I select the sketch that I wish to develop and tape it on to my drawing board. Over this I tape a sheet of tracing paper. It can be taped either to the edges of the sketch paper or to the support beneath. The tracing paper should be translucent enough so that the drawing beneath shows through clearly. Then, I refine the basic body shape on the tracing paper with a pencil.

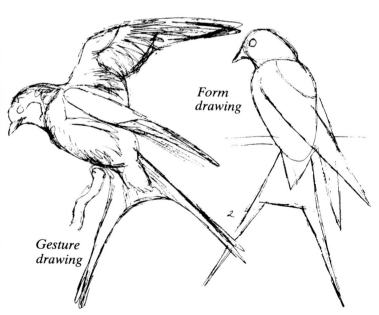

Form drawing

Gesture drawing

This hawk was ready to fly away, had he not been tethered. His position lasted only seconds, so I captured the idea of his shape and position using a gesture drawing.

Form drawing from a photograph

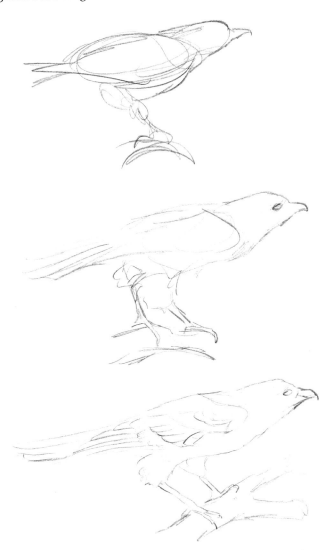

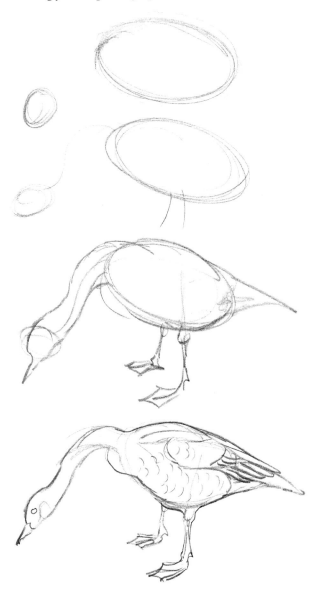

Then, I refined the drawing with the aid of other sources and my knowledge of bird anatomy.

Form drawing is useful for a bird that will sit very still, such as a long-eared owl (see page 11). The drawing can be refined as much as required.

Now I am ready to add detail, so a fresh sheet of tracing paper is taped over the first one. At this point, I refer to the photographs that I have taken. Alternatively, I may use other sources if necessary; mounted specimens, colour sketches, additional field sketches, or outside reference sources contained within my morgue file. Carefully, I draw in details such as wing feathers and markings. Small changes may be erased, but if I need to make a substantial alteration then I tape another sheet of tracing paper over the ones beneath and effect my change on this.

When I am satisfied that the final drawing is complete, it may be composed of several layers of tracing paper. I retrace the entire drawing on to one single sheet of tracing paper. This last sheet of tracing paper should be large enough to leave a margin around all edges of the watercolour paper, so that it may be taped to the support and not to the watercolour paper itself. The original sketch and tracing paper corrections are removed from the drawing board and put aside.

Next, I tape the edges of my watercolour paper lightly to the drawing board. On top of this goes some graphite transfer paper, coated side down. Over this I then place my completed single-sheet drawing. Using a ball-point pen, I trace over the lines of the drawing, using just enough pressure so that the drawing will transfer through the graphite paper to my watercolour surface. When I rest the heel of my hand on the paper as I transfer, I am careful not to smudge my drawing with excessive pressure. At times, I pick up a small corner of the graphite paper to check the transfer lines. When I have traced over the entire drawing, I remove the transfer paper to reveal a clean line drawing on my watercolour paper, which is now ready to paint.

Painting individual features

The following examples illustrate how to paint some of the basic features of a bird; the feathers, the leg and foot, the bill, and the eye. It is important to practise drawing and painting as diverse a range of these features as you can, as the wider your experience the more skilled you will become.

Stipple wash

A stipple wash can be used to give the appearance of feather texture. The bird's basic colour is put in first and left to dry. Stippling is then done with small, light brush strokes in the direction that the feathers grow. The stippling can be built up with two or three successively darker layers of paint. This layering technique gives the appearance of depth to the feathers.

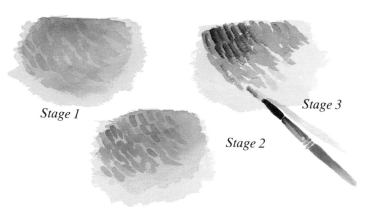

Stage 1

Stage 2

Stage 3

Feather detail

The shaft is the 'backbone' of the feather. Barbs extend outwards from the shaft, comprising the main body of the feather. Your painting should reflect the angle of the barbs accurately. They grow in the general direction of a bird's tail and never towards the head. Breaks are places where the barbs have separated and give a more realistic look to the painting. I indicate breaks with darker lines or paint them as an actual separation.

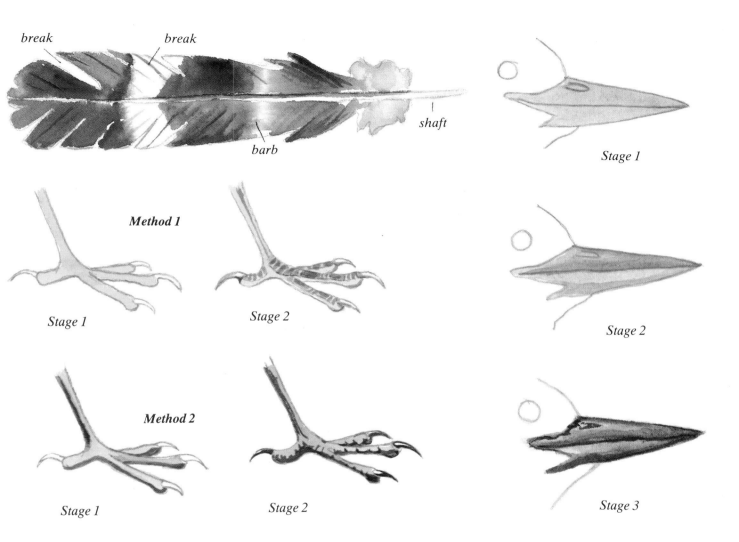

break *break*

shaft

barb

Stage 1

Stage 1 *Stage 2*

Method 1

Stage 2

Stage 1 *Stage 2*

Method 2

Stage 3

Leg and foot (method 1)
Block in a light value of the base colour. Then, paint the scales (the skin pattern) with the base colour. Leave a white highlight on the toenails, or use opaque white.

Leg and foot (method 2)
Block in the base colour and darken the shadow areas. Next, indicate the scales by painting around them with a dark value of the base colour.

Bill
Block in a very light value of the base colour. Then, add a middle value base colour, leaving the underwash showing along the bill for highlighted areas. Finally, use dark values to paint the nostril, shadows, and details.

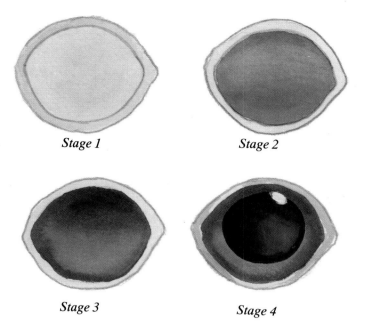

Stage 1 *Stage 2*

Stage 3 *Stage 4*

Coloured eye

Both the eye and eyelid are blocked in with grey and left to dry. Then, the eye is painted in with transparent colour. Brown is used here, but there is a wide variance in eye colour amongst the different species. Shading on the upper half and edges is done next, whilst the eye is still damp. Finally, the pupil is painted black, and an opaque white highlight is added when it is thoroughly dry.

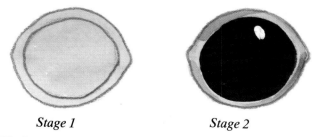

Stage 1 *Stage 2*

Black eye

Both the eye and eyelid are blocked in with grey and left to dry. Then, the entire eye is painted black, and an opaque white highlight is added when it is thoroughly dry.

Long-eared owl: demonstration

Original size: 37.5 × 55cm (15 × 22in)
Paper: Arches, 300gsm (140lb)
Brushes: No. 4 round, 2cm (¾in) flat
Colours: Hooker's green dark, sepia, burnt umber, black, yellow ochre, Prussian blue, cadmium orange, burnt sienna, Payne's grey, lemon yellow, opaque white, charcoal grey

At first, the plumage markings of the long-eared owl appear to be a never-ending complexity. When these markings are simplified, they translate into a varied pattern of bars and dots, which was all I found necessary to achieve the desired results.

The completely refined drawing was rendered as the owl sat quietly, tethered to his open-air perch at a wildlife centre. He looked quite bored as he yawned, fluffed his feathers, and looked all around.

For the painting, I decided to change his perch. He was tethered to an iron 'T' bar, which had no aesthetic value. I substituted a sawn-off pine log, being careful to position the branches in a way that would balance the composition. The pine log was done purely from my imagination, and the needle branches were drawn and painted from a specimen in the studio.

Stage 1 (overleaf) shows the completely refined drawing, ready to paint. The colour was added later at the studio, from several photographic references that I took with my 35mm camera and 300mm lens. A No. 4 brush was used for the subject-matter, whilst a 2cm (¾in) flat brush was used for the background.

Form drawings
The owl is a combination of ovals and circles, which are modified until the proper proportions are defined. This may take several attempts.

Stage 1

Light washes are laid in first. I use burnt umber on the head and breast, and a mixture of burnt sienna and cadmium orange for the facial discs. Each lower breast and abdomen feather is shadowed to the left and bottom with dilute mixes of Prussian blue and burnt umber. A soft brown made from sepia, with Prussian blue and burnt sienna, blocks in the tail. The feathered feet are coloured with a light reddish-brown mix of yellow ochre, burnt sienna, and burnt umber.

Stage 2

Now, I can darken the facial discs if necessary. The vertical markings of the breast feathers are defined with burnt umber and sepia. All of the back and wing feathers are washed in with a warm grey mix of sepia, charcoal grey, and cadmium orange. The reddish areas have some burnt sienna added. The lower breast and abdomen feathers are redefined with darker washes of Prussian blue and burnt umber. Thin sepia is used for shadows on the feet. A strong lemon yellow wash colours the eyes. I begin to model the pine trunk with charcoal grey, Prussian blue, sepia, and burnt umber.

Stage 3

Here, the dark facial markings are toned in with charcoal grey. I work carefully around the eye area with my brush tip, as it is important to preserve the clean yellow of the eyes. Now, the upper half of each eye is filled in with a thin shadow of burnt sienna. Soft grey tones the bill.

The lower breast and abdomen markings are painted next, with light umber washes. The feathers in this area lie in rough columnar rows, with the markings seeming to follow one another down the front of the bird, in an orderly fashion. If they are painted facing different ways, then the result could look like an unhappily ruffled owl.

The green pine needle areas are blocked in with varying washes of Hooker's green dark and burnt umber. I do not worry about painting in the actual needles yet, as I am only interested in establishing an area of colour. Any clusters directly in front of the others are left unpainted for now.

I wash a very light tone of reddish brown on the cut

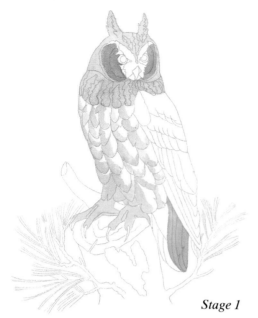

Stage 1

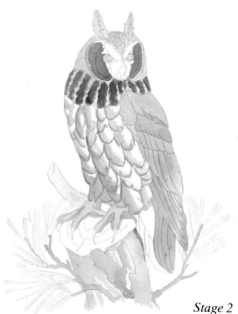

Stage 2

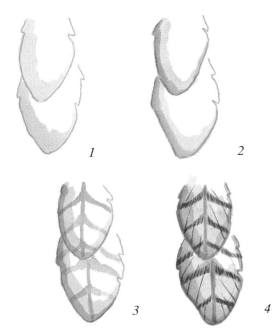

1

2

3

4

Steps to painting the breast and abdomen feathers

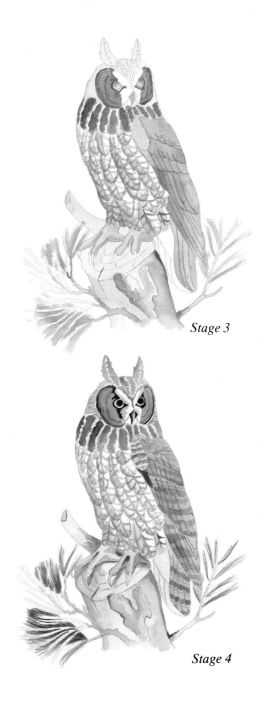

Stage 3

Stage 4

end of the trunk, and further define the sides and branches with sepia.

Stage 4

Slightly darker burnt umber and sepia enhances the ear tufts and creates the rows of vertical markings on the forehead. I also stipple some of this wash on both sides of the head, around the facial discs. Both the white moustache and bill are now shaded with sepia.

I use a medium wash of sepia and burnt umber to paint bars of varying width on the back, wing, and tail. The undertail is washed in with a very dilute mix of the same. Varying washes of sepia are used to model the feet further, and to shadow the cut end of the trunk. A strong shadow goes under each talon.

Next, I darken the facial markings with black. Some of the charcoal grey shows through as a highlight. A black shadow is also painted on the left side of the bill.

Now, the black pupils are added with a solid layer of paint. Very thin Payne's grey colours the talons. I begin to paint the individual pine needles with dark mixes of Hooker's green dark, also adding charcoal grey, sepia, and burnt umber.

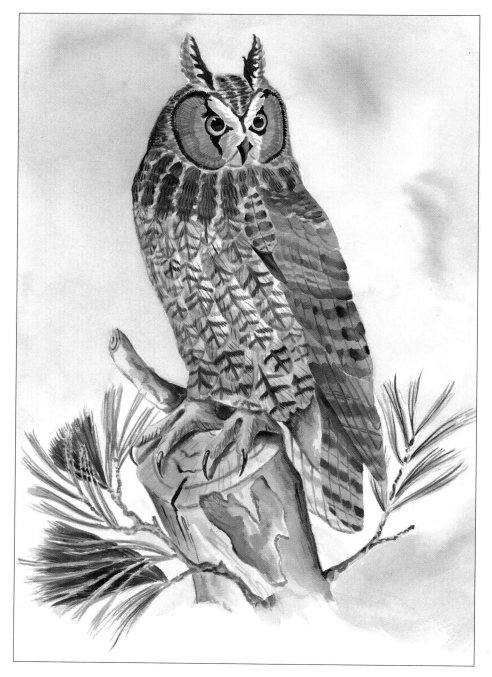

Stage 5 – the finished painting

With mixes of sepia and burnt umber, I define all of the markings on the owl, including the ear tufts. I use some of this mix to darken the shadows on the feet, tree stump, and undertail. A thin wash of burnt sienna tints some of the lower breast and abdomen feathers and the small triangular space under the bill. Black finishes the talons, with the grey-blue underwash showing through as a highlight. A small amount of lemon yellow is placed inside the bottom half of each pupil, to give the effect of 'inner light'. I work into the pine needles with more dark washes, then stroke in brighter greens made from Hooker's green dark, yellow ochre, and lemon yellow.

Now, I pre-wet the sky and drop in Payne's grey washes, blending them softly. It is not necessary to cover all of the white paper around the trunk and branches.

Stage 5 – the finished painting

European goldfinch: demonstration

Original size: 19 × 20.5cm (7½ × 8in)
Paper: Arches, 300gsm (140lb)
Brushes: No. 4 round
Colours: Winsor red, cadmium red deep, burnt umber, sepia, mauve, opaque white, Prussian blue, Hooker's green dark, lemon yellow, new gamboge, burnt sienna, black

The original mounted specimen was in this pose.

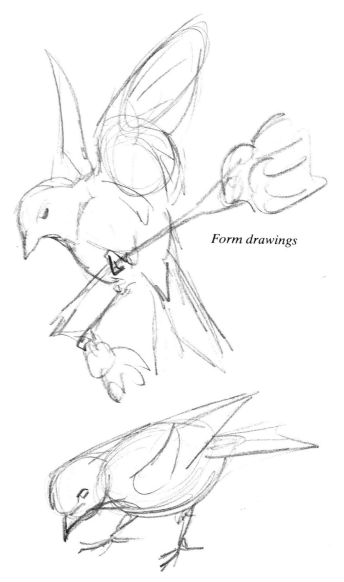

Form drawings

These are the changes that I made based on my knowledge of bird structure. It helped being able to see all sides of the mounted specimen.

The finished painting of the European goldfinch began as a form drawing of a mounted museum specimen. In order to give my drawings more life, I relied on my knowledge of bird structure to make sketches of the bird in several imagined positions. Afterwards, I took several photographs with my 35mm camera. The thistle flower was picked from a stray weed growing in my back garden, and painted from life.

Stage 1 (overleaf) is the drawing that I finally chose for the painting. The details and colour in each of the stages were added from my photographic references of the mounted bird. The entire painting was done with a No. 4 brush. Although the portrait is simple in composition, the colours of the face and thistle flowers are vibrant when played off against the muted tones in the rest of the painting.

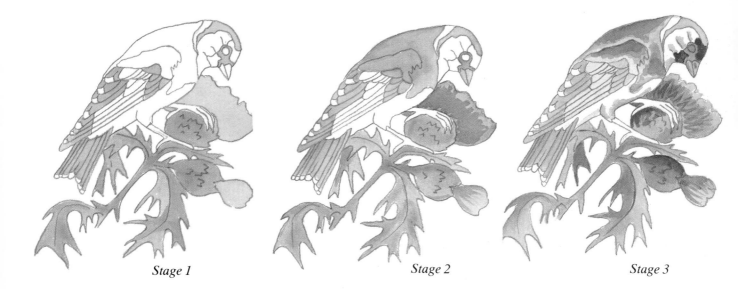

Stage 1 *Stage 2* *Stage 3*

Stage 1

I begin by blocking in the head, wing, and tail sections with a plain grey wash made from diluted black. The thistle flowers are filled in with mauve. Hooker's green dark, dulled with a touch of sepia, tones the green areas of the plant.

Stage 2

Next, I wash a thin grey-brown mix of burnt umber and sepia on the bill and body section. The lower two-thirds of the thistle flowers are enhanced with a slightly darker mauve and Prussian blue mix, which is put on after the first wash is dry.

Stage 3

The back, shoulders, and chest area are built up with successive layers of a grey-brown wash, each put on when the previous ones have dried. I begin to shadow the green parts of the thistle plant with a darker mix of Hooker's green dark and sepia.

The face is painted with a rich, but not opaque, wash of Winsor red. You might be tempted to achieve the brighter colours with a thick application of paint, when, in fact, just the opposite is true. The white paper showing through from beneath is what gives these colours their vibrancy. When this first wash is dry, the lower forehead and area near the white face patch are overpainted with cadmium red deep. This two-tone application gives a shading effect whilst retaining the intensity of the colour.

With my brush tip, I begin to texture the thistle flowers. Their soft, fluffy, brush-like appearance is suggested with fine lines and a darker mix of mauve and Prussian blue. I concentrate most of this texture on the lower two-thirds of the flower-heads to give an effect of light shining through their tops. Shadows on the bird's face patch and abdomen are applied using Prussian blue dulled with sepia. Pale lemon yellow goes on the wing patch.

Now, I use a burnt sienna wash for the eye area, and whilst it remains damp I move on to stage 4.

Stage 4 – the finished painting

Just a touch of burnt umber in my brush tip darkens the upper half of the eye. This is left to dry before the pupil and highlight are added.

A stipple is now applied to the brown areas of the body. It is more concentrated and slightly darker in value along the top of the back and shoulders. If the entire section is painted evenly, then the bird will look

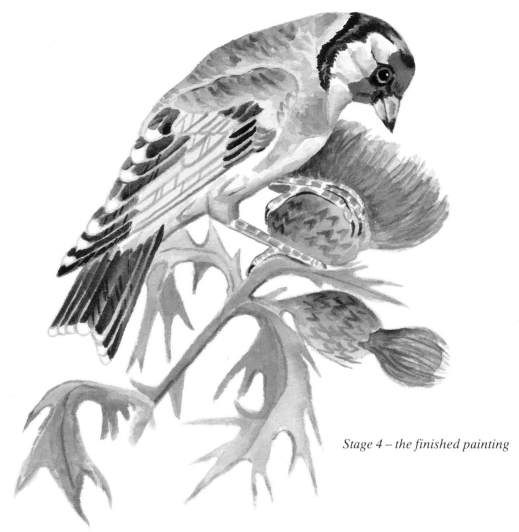

Stage 4 – the finished painting

flat. Leg detailing is done with a grey-pink mix of cadmium red deep and black.

The head, wing, and tail sections that I have blocked in with grey during stage 1 now receive a wash of black. The grey shows through in places as a highlight. In addition, thin spaces of grey are left around each darkened feather for definition.

I finish with details such as black for the toenails and beak tip, and possibly a thin, dark shadow directly under the feet. The yellow wing patch is detailed with a darker yellow wash of new gamboge along each feather edge. The white tail tip is defined with a very thin outline of light Prussian blue. Final barb-like texture on the thistle flower base is done with v-shaped lines of Hooker's green dark and sepia. Shadows on the plant and bird's abdomen can be enhanced with sepia, if necessary. Lastly, feather breaks are added sparingly to the wing and tail.

Pintail drake: demonstration

Original size: 37.5 × 55cm (15 × 22in)
Paper: Arches, 300gsm (140lb)
Brushes: No. 4 round, 2cm (¾in) flat
Colours: Alizarin crimson, black, burnt sienna, yellow ochre, sap green, burnt umber, Prussian blue, Payne's grey, Davy's grey, opaque white

This pintail drake was alone on a lake when I spotted him. He was a shy and wary bird, and I knew that I would not have much of a chance to sketch him if he should discover how close I was to him, albeit inside my duck blind.

Stage 1 was based on the gesture sketches made at the lake. The detail in the refined drawing and the colours in all of the stages were based on two references; colour notes taken at the lake and a beautiful mounted specimen borrowed from a friend.

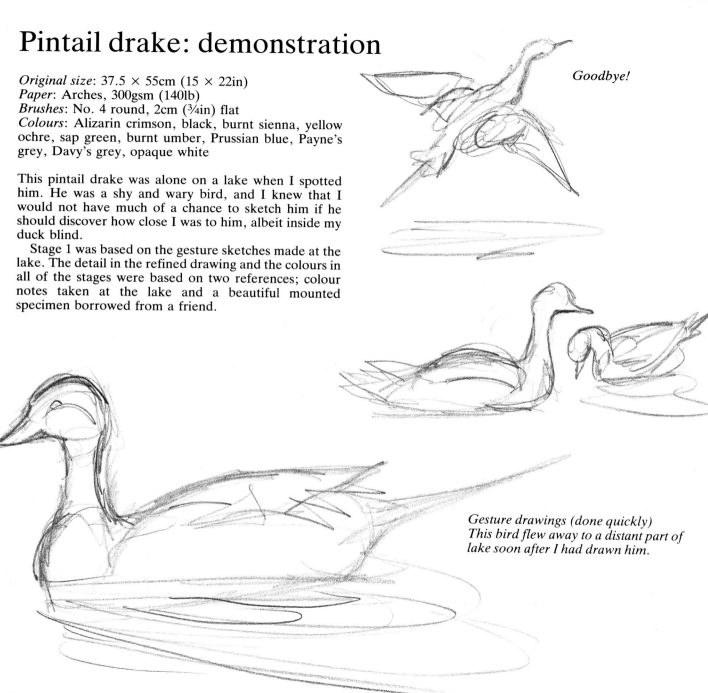

Goodbye!

Gesture drawings (done quickly)
This bird flew away to a distant part of lake soon after I had drawn him.

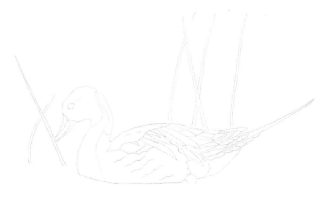

Stage 1

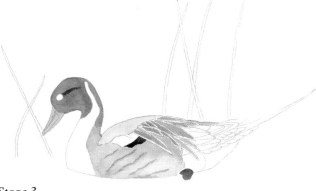

Stage 3

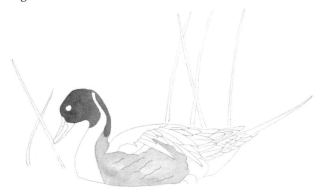

Stage 2

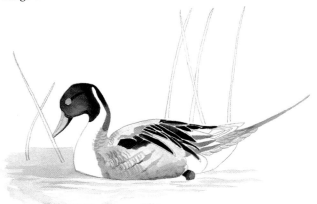

Stage 4 (overleaf)

Stage 1

When drawing ducks, an important point to note is that very little of the wing shows when a duck is at rest. This is because it fits into areas called side pockets. On this pintail drake, the long, downward-pointing scapulars also cover much of the wing area, leaving some of the primaries and tertials in view.

Stage 2

The entire side area is blocked in with light Davy's grey. Now, I use a medium mix of burnt sienna, alizarin crimson, and black to lay in a reddish-brown tone to the head. This is left to dry as I move on to stage 3.

Stage 3

A furrow called the eye trough runs along the upper cheek area. This is defined with a shadow of diluted black. I use a dark wash of sap green and black for the speculum, which is the small, often brightly coloured patch found on the wing feathers and visible here directly in front of the scapulars. All of the scapulars are coloured with varying light grey mixes made from Davy's grey, Prussian blue, and black. Light yellow ochre colours the back. The bill and leg are blocked in with Payne's grey. The diagonal lines on the side of the duck represent shadows which define the rows, or tracts, of feathers. These are applied with a soft grey.

Stage 4 (page 19)

The soft, graduated shine on the head is made from working the colours wet in wet. I rewet the head with clear water and drop in a rich brown made from burnt sienna, black, and alizarin crimson. Just a small amount of this last colour is needed or the head will become too red. Whilst this is still wet, pure black from the tube is dropped into the darkest areas and blended softly with the brush. When this is dry, Payne's grey colours the eye. Black models the leg and edges the lower part of the bill.

Now, all the scapulars are darkened. I want them to have the effect of glossy shine, so I use light and dark washes of black, and black mixed with burnt sienna. An edge of white is left around each one. The bottom halves of the three visible tertial feathers are painted with a mix of opaque white and Payne's grey.

I colour the tail and upper tail coverts with Payne's grey. Shadows on the lower side of the body, and the feather tract lines, are washed in with burnt sienna dulled with Prussian blue. The many small lines on the side of the body are 'vermiculations'. I suggest these with grey made from black and Prussian blue, following the feather tract lines.

Some ribbons of water are started with the 2cm (¾in) flat brush and light Prussian blue.

Stage 5 – the finished painting

For the highlight on the upper cheek, I lighten some of the head mix with white and apply it to the area, softly blending the edges with the tip of a clean, damp brush. The nostril and the dark patch down the centre of the bill are painted with Payne's grey and black. Next, I paint the eye with solid black, leaving a thin rim of base colour.

The vermiculations are finished, and also painted on to the back. I want some added sparkle, so white paper is left to show around the primaries. In addition, the shafts of both primaries and tertials are left white. Black and Prussian blue finish the upper half of the tertials. Varying mixes of black and burnt sienna are used for the primaries.

The upper tail coverts are enhanced with Payne's grey. A strong black wash goes on the long tail feathers, with some undercolour showing through as a highlight. All of the shorter tail feathers are enhanced with very

Steps to drawing the vermiculations

1

2

3

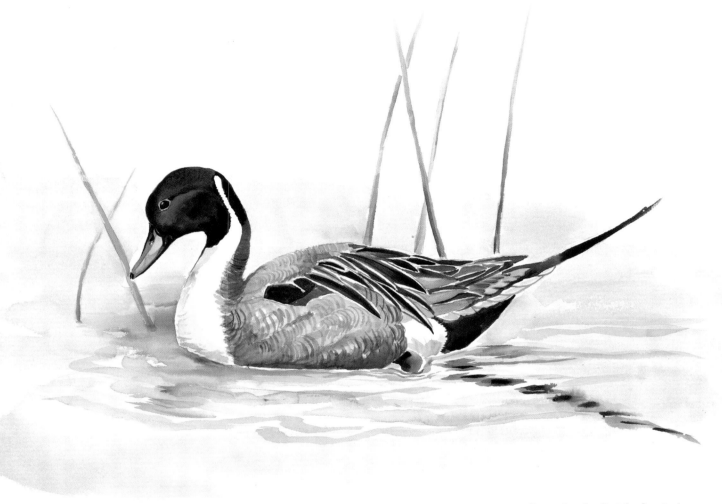

Stage 5 – the finished painting

light Davy's grey and Payne's grey. Strong washes of black go on the undertail patch.

Now, warm and cool shadows model the white front section and the patch behind the leg. Pale washes of Prussian blue and yellow ochre are used. The yellow ochre goes on first and is left to dry before Prussian blue is put in for the darker areas.

I finish the water with ribbons of blue and grey made from Prussian blue, Davy's grey, and Payne's grey. The background is washed in with light Prussian blue. Plenty of white, unpainted paper is left between these washes to give the water sparkle.

When all this is dry, the grass blades are painted with sap green and then shadowed with burnt umber. Finally, I work a little reflection into the water with some of the colours used on the duck.

Lyrebird: demonstration

Original size: 32.5 × 41cm (13 × 16½in)
Paper: Arches, 300gsm (140lb)
Brushes: No. 4 round
Colours: Burnt umber, burnt sienna, black, Prussian blue, sepia, cadmium orange, sap green, opaque white

Since I did not have access to a living or mounted specimen, it was necessary to rely on outside reference sources. I got together as many different photographs of lyrebirds as I could find. Two of the photographs came from my morgue file and three came from library books.

Combination of gesture and form drawings

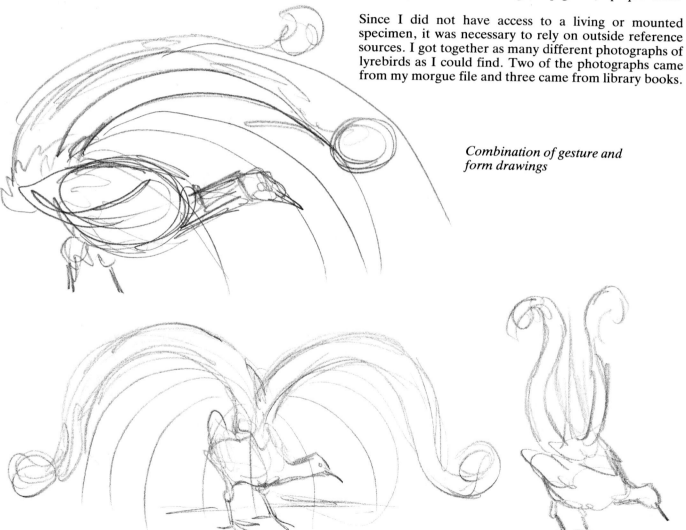

My most important problem was to position the bird to show as much of its beautiful tail as possible without dwarfing the bird. I made many sketches of lyrebirds in different positions, using the reference sources as a guide, but relying on my imagination to position the bird. Finally, I decided to shorten the tail length, but succeeded in projecting the effect of a large tail by letting the centre, lacy feathers fall over the body in a gentle, veil-like position.

After refining the drawing and transferring it to my watercolour paper, I relied on my reference sources to colour all of the stages.

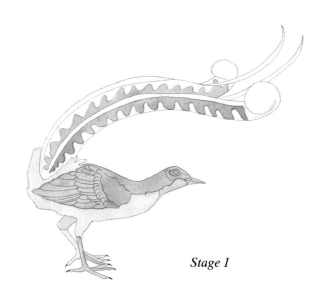

Stage 1

Stage 1

Light tones of brown and grey are blocked in first. Burnt sienna is the main ingredient for the reddish-brown areas. I vary this by adding the following colours to the burnt sienna; cadmium orange for the upper tail feather, burnt umber on the wing and upper body, and sepia for the legs and lower tail feather.

The live bird has a patch of blue skin around the eye, so this area on my portrait is Prussian blue. Sepia with the slightest hint of Prussian blue creates an ashy tone for the underside and bill.

Stage 2

Now, I begin to build up the previously blocked in areas. Working from light to dark, I layer washes of burnt umber along the lower tail feather. A touch of black is added for the darkest sections on the underside.

The reddish areas on the body are toned down with a darker wash of burnt umber and sepia. This colour is also used on the wing, with the exception of the long primary and secondary feathers. These are to remain reddish brown, so here I use more burnt sienna and burnt umber. I am careful to let the original wash show in areas around each wing feather. This keeps them defined, and later they will be blended with an overglaze.

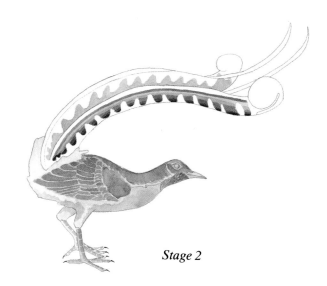

Stage 2

Next, I use the tip of my brush to paint in the tiny feathers on the throat, using burnt sienna.

Leg details are done with sepia. Shadows on the underside of the bird are done in layers. The first and largest shadow is a dilute mix of sepia and burnt sienna. This is left to dry as I move on to stage 3.

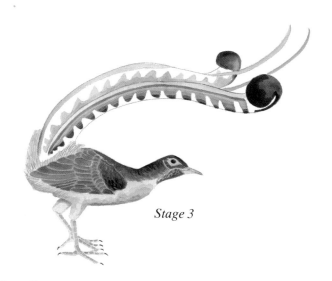

Stage 3

Stage 3

A strong application of burnt umber mixed with sepia stipples the dark body and upper wing. The darkest areas are pure black paint. Thinned burnt umber glazes the rest of the wing.

Darker burnt sienna defines the throat. The eye is painted solid black, then highlighted. Thin sepia shades the bill and both tail feathers. Layers of sepia build the shadows of the underbody. The fluffy looking feathers at the base of the tail are drawn in with more sepia and many fine, overlapping lines.

I colour the pointed tail feathers with dilute blue-grey made from Prussian blue and black. To do the rounded tail tips, I dampen them and drop in black, Prussian blue, and burnt umber straight from the tube.

Stage 4 – the finished painting

The ground area is painted with sap green and burnt umber. A burnt umber shadow is applied under the feet.

The lacy tail feathers are added last. In life, only the undersides of these feathers are white. When the lyrebird arches them over his back in display, these are the sides that show. Here, I use a pale grey-blue to represent them on the white background. If you are unsure of placement, then a few of the feather shafts can be sketched in for guidance. I begin by using opaque white mixed with a little black and Prussian blue to paint in all of the feather shafts.

A lot of patience is needed to complete the last step, but this is the stage that I find to be the most rewarding. Enough water must be added to the paint to keep it flowing smoothly, because each barb should be completed in one unbroken stroke. Here, a No. 3 or smaller brush can be used. I prefer the No. 4 because it holds more paint, and I do not have to reload it so often. As I paint the individual barbs, I am careful to keep them uniform in thickness and length. In places where the feathers come close to one another, the barbs are painted to overlap. This creates the lacy effect.

Variation of the final painting

This variation of the final painting is made by dropping very strong washes of colour next to each other and letting them blend softly. Here, I use burnt umber, black, and sap green. When everything is thoroughly dry, opaque white does the tail, with just enough water added to keep a smooth flow of paint.

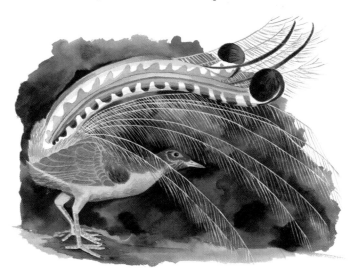

Variation of the finished painting

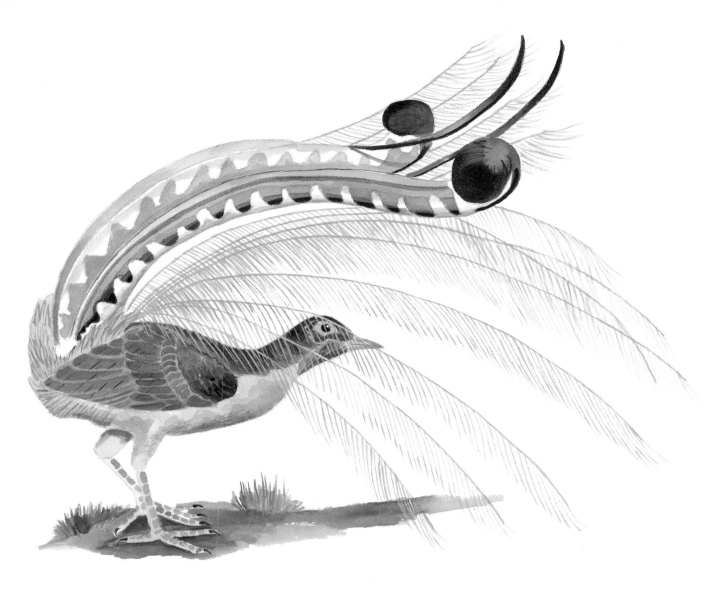

Stage 4 – the finished painting

25

Barn swallow: demonstration

Original size: 25 × 30cm (10 × 12in)
Paper: Arches, 300gsm (140lb)
Brushes: No. 4 round
Colours: Yellow ochre, sepia, Hooker's green dark, phthalo blue, black, Prussian blue, burnt umber, Winsor red, cadmium orange, burnt sienna, opaque white

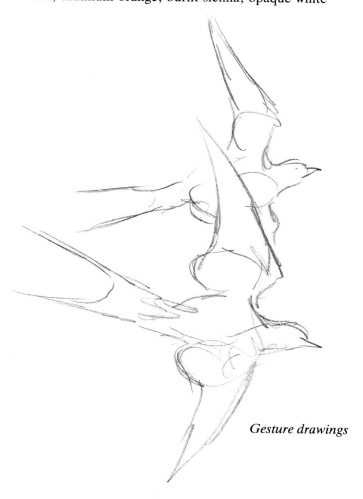

Gesture drawings

I have a special feeling for swallows. They are graceful little birds that flash in the sun like flying jewels. Here, I have tried to capture some of that delicate beauty. I wish that I could paint their friendliness too!

I made this study at a pond which, in the summer, is a meeting place for two types of swallow. On any given day, it is possible to see the steel-blue barn swallows with their chestnut undersides weaving their flight with the tree swallows, which are iridescent green on top and white below. I did many colour notes at the pond and the swallows were bold and friendly, returning my attentions by flying past almost within reach. I made two pages of gesture drawings before making my final choice. The detail in the final drawing and the colours in all of the stages were added with reference to photographs of nesting swallows, which were taken at a public park by a photographer friend with a 500mm lens.

The flower in the painting is a cardinal-flower. I thought it would make a nice supporting element, along with some blades of grass, to echo the swallow's gracefulness. The flower was painted from a photograph that I had taken of the wild, living plant in its natural habitat.

Stage 1
Light yellow ochre blocks in the underwing and body. The grass blades are made with a thin wash of Hooker's green dark.

Stage 2
When the ochre is thoroughly dry, I add a shadow to the body with a mix of thin yellow ochre and sepia.

I use a warm grey made from black, phthalo blue, and a touch of burnt umber to colour the feet, tail, and remaining wing. The barn swallow has small white markings on the lower edges of the outer tail feathers, which I have left unpainted.

Next, to achieve the soft shine on the head and upper tail coverts, the wash that I lay down must remain damp as another application of paint is added. I use light phthalo blue for the initial wash, and move on to stage 3.

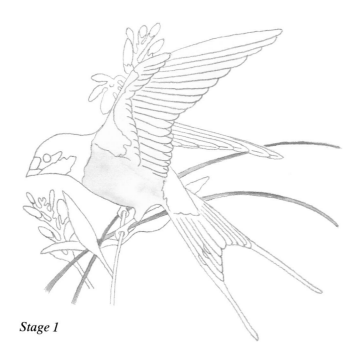

Stage 1

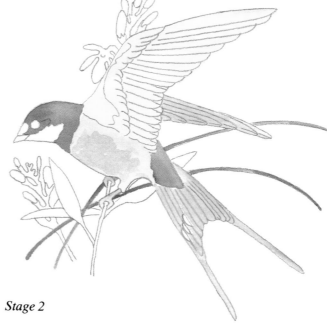

Stage 2

Stage 3

Now, I drop a dark, ink-like mix of Prussian blue and black into parts of this damp underwash. The effect of shine is created when the two values blend together.

The underwing and body are developed with more sepia and yellow ochre shading. In addition, a shadow goes along the underside of each wing feather where they overlap. To deepen these shadows, I use the mix in successive layers.

The feathers of the remaining wing and the tail are now painted individually with a slightly darker wash of black, phthalo blue, and burnt umber. Areas of the underwash are left to show in a thin line around each feather. Some of this colour is also used for the bill and eye area.

Using Hooker's green dark brightened with a little yellow ochre, I block in the green areas of the cardinal-flower. The flowers themselves are coloured with Winsor red.

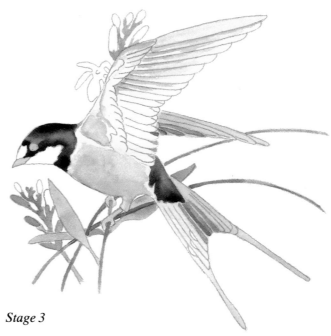

Stage 3

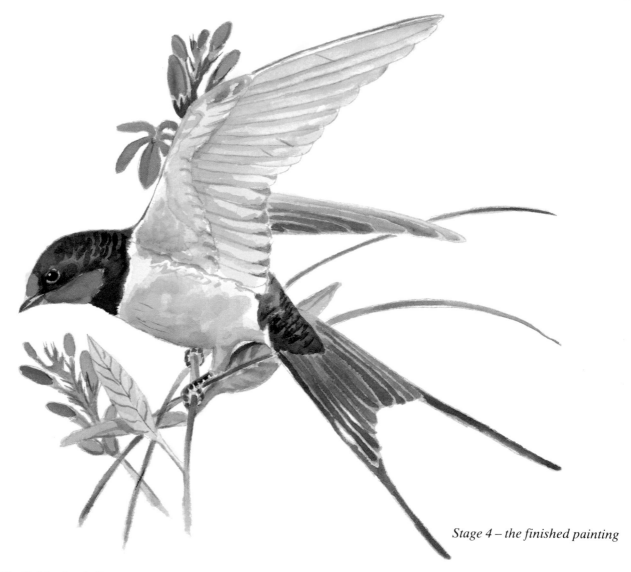

Stage 4 – the finished painting

Stage 4 – the finished painting

The flowers are finished with dark shadows made of a Winsor red and sepia mix. Burnt umber and Hooker's green dark make the shadows and veining on the stems and leaves.

Now, I do the chestnut throat and forehead of the swallow using burnt sienna mixed with small touches of cadmium orange and Winsor red. At this point, the ochre sections are further developed with sepia shadows and additional shadows of the blue-grey mix. The bill and feet are detailed with dark grey and black. The eye is burnt sienna, with a large black pupil and opaque highlight.

Finally, the blue head and upper tail coverts are stippled with the tip of the brush, using black paint.

Canada goose: demonstration

Original size: 37.5 × 55cm (15 × 22in)
Paper: Arches, 300gsm (140lb)
Brushes: No. 4 round, 2cm (¾in) flat
Colours: Hooker's green dark, Prussian blue, black, burnt umber, yellow ochre, raw umber, sepia, opaque white

*Combination of
gesture and
form drawings*

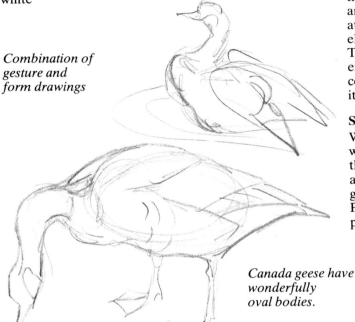

*Canada geese have
wonderfully
oval bodies.*

I have painted the Canada goose more times than any other bird subject. It is a perfect combination of light, medium, and dark values.

The drawing began as one of several form drawings of geese on a local pond. On that day, there were about fifty geese and black ducks on and near the water, quite accustomed to people. I refined the sketch of my choice, putting in as much detail as possible whilst observing the geese. I was fortunate to be able to capture all but the smallest details at the lake, because of my familiarity with the subject and also because of their proximity.

Stage 1 shows the completely refined drawing, ready to paint.

Later, at the studio, I did the colour steps with the aid of photographs that I had taken whilst at the lake. The photographs were especially helpful when I was placing the shadows around the primary wing feathers. The nest and background details were added from my imagination, and I was careful to lace these supporting elements in positions that would balance the picture. The handsome, understated look of the goose was enhanced by keeping the background muted and confining the lightest and darkest values to the goose itself.

Stage 1

With my 2cm (¾in) flat brush, I lay in the background with a very thin wash of Prussian blue, not much more than tinted water. The No. 4 round brush is used to work around the smaller areas. Whilst this is still damp, the grass is stroked in with a mix of Hooker's green dark and Prussian blue. This should soften and blur on the damp paper.

Stage 1

Stage 2

The rest of the painting is done with a No. 4 brush. When stage 1 is dry, light tones of brown are added. Burnt umber is used on the goose, and a sepia and raw umber mix is applied to the stumps and nest. Plenty of water is used in these washes to keep them light. The grasses are enhanced with an additional blue-green mix, stroked on after the first wash is dry.

The legs are coloured with a blue-grey made of Prussian blue and black. Now, I wet the head and neck evenly, leaving the white cheek patch. A strong wash of black is put all along the underside. As it begins to soften into the unpainted (highlighted) areas, I help it along with my brush tip if necessary. I continue working wet in wet as I drop a thin blue-grey mix of Prussian blue and black into the highlight areas to give them a little colour.

Stage 3

The feathers of the back are now defined with a slightly stronger mix of burnt umber and raw umber. The wing feathers are darkened with a mix of sepia, burnt umber, and black. Whilst the longer, primary wing feathers are still damp, I shade some of them where they overlap, using black and sepia. The back and wing feathers are painted individually, with areas of base colour from the previous stage showing around each one.

Sepia washes are used to shadow the stumps and nest, and to tone the grey sides of the goose. The eye and bill are coloured with a blue-grey mix of Prussian blue and black.

Stage 4 – the finished painting

The back and wing area must be toned down and pulled together, so I glaze this section with a thin mix of sepia, burnt umber, and yellow ochre. I drop some sepia shadows into this wash before it dries. The feather detailing on the grey sides of the goose is done with a medium sepia wash.

I model the legs with black, leaving the underwash showing through in places as a highlight. Sparingly, I use burnt umber to darken the section behind the nest, and for the darker grasses.

The bill is finished in grey values, using thin washes of black. Solid black is used for the eye, leaving a very thin ring of base colour showing around the rim. A white highlight is added when it is thoroughly dry.

The eggs are modelled using a Prussian blue and sepia mix for the shadows and yellow ochre and sepia for the lighter parts. A white highlight is left on each egg. Each wash is left to dry before another is added, otherwise the colours could blend and an unwanted green may result. The white cheek patch and undertail section are also worked in the same colours and the same manner, with

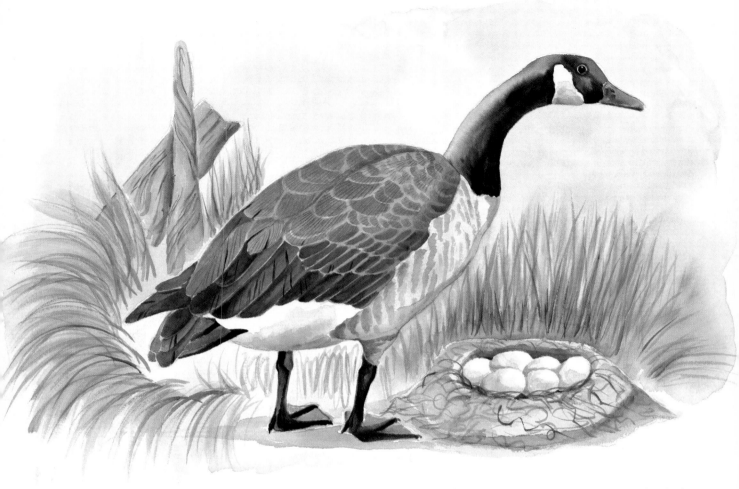

Stage 4 – the finished painting

the darker wash being put on first and then working up to the lighter. Varying washes of black and raw umber do the tail.

With the tip of my No. 4 brush, I detail the stumps by drawing fine lines of varying thickness, to represent old, cracked wood. I complete the nest in the same way, using varying lines for the grasses and reeds of which the nest is made. A thin wash of sepia goes beneath the feet.

The painting is finished by fine lines of feather detailing, to indicate breaks and barbs. I am careful not to get carried away with this, or the finished bird will look frazzled.

First published in Great Britain 1992
Search Press Limited,
Wellwood, North Farm Road,
Tunbridge Wells, Kent TN2 3DR

Text, drawings and paintings by Betsy Lee Wanner

ISBN 0 85532 677 8

The author would like to thank Lisa Grogan for her help with the
book.

Publishers' note
There are references to sable hair and other animal hair brushes in this
book. It is the Publishers' custom to recommend synthetic materials as
substitutes for animal products wherever possible. There are now a
large number of brushes available made of artificial fibres and they are
just as satisfactory as those made of natural fibres.

Distributors to the art trade:

UK

Winsor & Newton,
Whitefriars Avenue, Wealdstone,
Harrow, Middlesex HA3 5RH

USA

ColArt Americas Inc.,
11 Constitution Avenue, P.O. Box 1396, Piscataway, NJ 08855–1396

Arthur Schwartz & Co.,
234 Meads Mountain Road, Woodstock, NY 12498

Canada

Anthes Universal Limited,
341 Heart Lake Road South, Brampton, Ontario L6W 3K8

Australia

Max A. Harrell,
P.O. Box 92, Burnley, Victoria 3121

Jasco Pty Limited,
937–941 Victoria Road, West Ryde, N.S.W. 2114

New Zealand

Caldwell Wholesale Limited,
Wellington and Auckland

South Africa

Ashley & Radmore (Pty) Limited,
P.O. Box 2794, Johannesburg 2000

Trade Winds Press (Pty) Limited,
P.O. Box 20194, Durban North 4016

Composition by Genesis Typesetting, Rochester, Kent

Printed in Spain by Elkar S. Coop.